THE GIFT OF THE MAGI

AND **THE PURPLE DRESS**

COLLINS | DESIGN

An Imprint of HarperCollins*Publishers*

O. HENRY

THE GIFT OF THE MAGI

AND THE PURPLE DRESS

ILLUSTRATED BY **CHRIS RASCHKA**

THE GIFT OF THE MAGI

One dollar and eighty-seven cents. That was **all**.
And sixty cents of it was in pennies.

Pennies saved one and two at a time by bulldozing the grocer and
the vegetable man and the butcher until one's cheeks burned
with the silent imputation of parsimony that such close dealing implied.
Three times Della counted it. One dollar and eighty-seven cents.

And the next day would be
Christmas.

There was clearly nothing to do but flop down on the shabby little couch and howl. So Della did it.

Which instigates the moral reflection that life is made up of

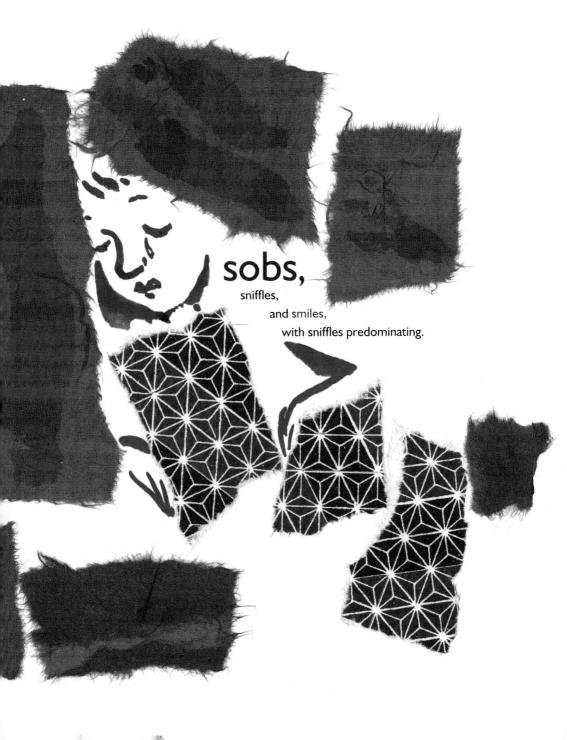

sobs,
sniffles,
and smiles,
with sniffles predominating.

While the **mistress**

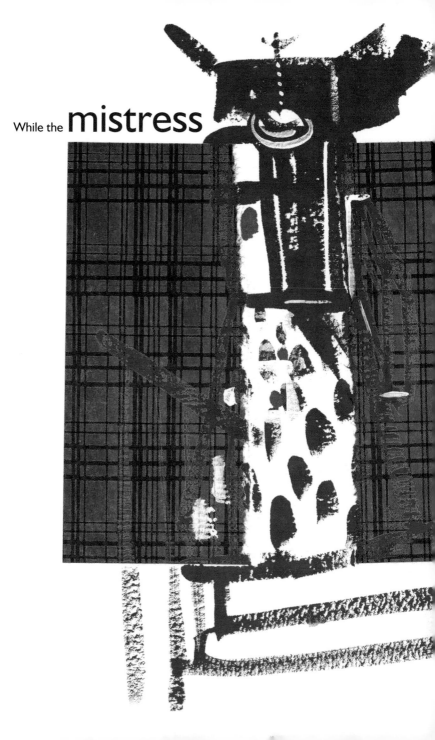

of the home is gradually subsiding from the first stage
to the second, take a look at the home.
A furnished flat at $8 per week. It did not exactly
beggar description, but it certainly had that
word on the lookout for the mendicancy squad.

In the vestibule below was a letter-box into
which no letter would go, and an electric button
from which no mortal finger could coax a ring.
Also appertaining thereunto was a card bearing
the name "Mr. James Dillingham Young."

The "Dillingham" had been flung to the
breeze during a former period of prosperity
when its possessor was being paid $30 per week.
Now, when the income was shrunk to $20,
the letters of "Dillingham" looked blurred,
as though they were thinking seriously of
contracting to a modest and unassuming D.
But whenever Mr. James Dillingham Young
came home and reached his flat above
he was called "Jim" and greatly hugged by
Mrs. James Dillingham Young, already
introduced to you as Della. Which is all very

good.

strips,

Della finished her cry and attended to her cheeks with the powder rag. She stood by the window and looked out dully at a gray cat walking a gray fence in a gray backyard. Tomorrow would be Christmas Day, and she had only $1.87 with which to buy Jim a present. She had been saving every penny she could for months, with this result. Twenty dollars a week doesn't go far. Expenses had been greater than she had calculated. They always are. Only $1.87 to buy a present for Jim. Her Jim. Many a happy hour she had spent planning for something nice for him. Something fine and rare and sterling—something just a little bit near to being worthy of the honor of being owned by Jim.

There was a pier-glass between the windows of the room. Perhaps you have seen a pier-glass in an $8 flat. A very thin and very agile person may, by observing his reflection in a rapid sequence of longitudinal obtain a fairly accurate conception of his looks. Della, being slender, had mastered the art.

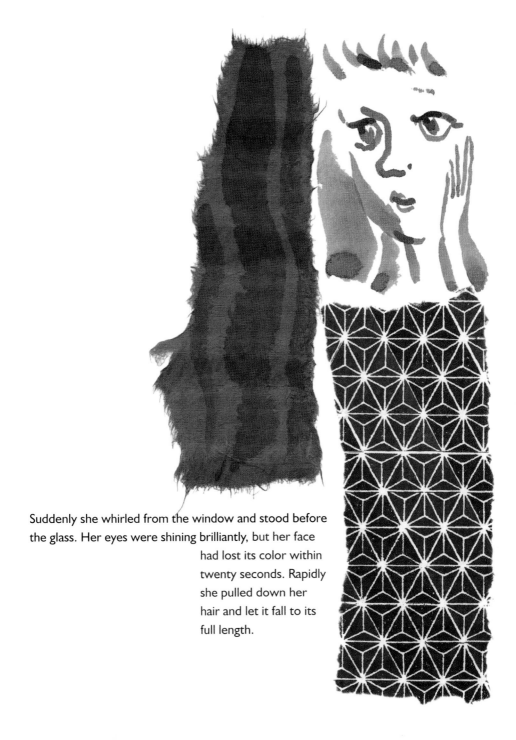

Suddenly she whirled from the window and stood before the glass. Her eyes were shining brilliantly, but her face had lost its color within twenty seconds. Rapidly she pulled down her hair and let it fall to its full length.

Now, there were two possessions of the James Dillingham Youngs in which they both took a mighty pride. One was Jim's gold watch that had been his father's and his grandfather's. The other was Della's hair. Had the Queen of Sheba lived in the flat across the airshaft, Della would have let her hair hang out the window some day to dry just to depreciate Her Majesty's jewels and gifts. Had King Solomon been the janitor, with all his treasures piled up in the basement, Jim would have pulled out his watch every time he passed, just to see him pluck at his beard from envy.

So now Della's beautiful hair fell about her rippling and shining like a cascade of brown waters. It reached below her knee and made itself almost a garment for her. And then she did it up again nervously and quickly. Once she faltered for a minute and stood still while a tear or two splashed on the worn red carpet.

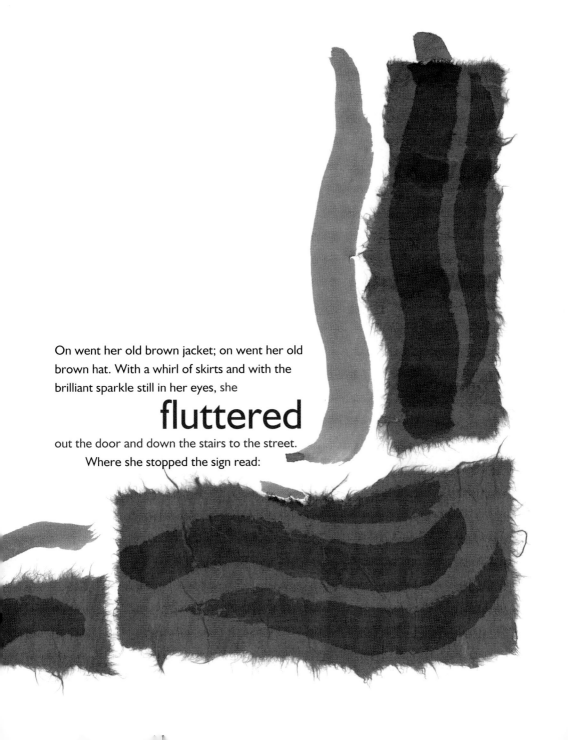

On went her old brown jacket; on went her old brown hat. With a whirl of skirts and with the brilliant sparkle still in her eyes, she

fluttered

out the door and down the stairs to the street. Where she stopped the sign read:

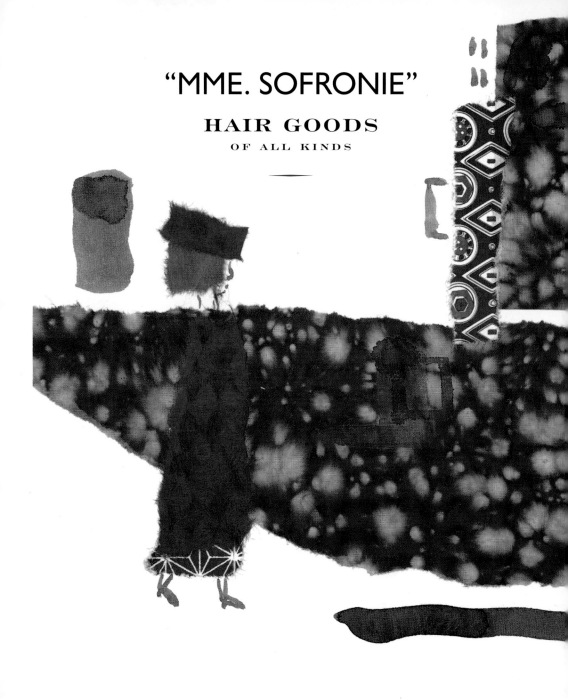

"MME. SOFRONIE"

HAIR GOODS

OF ALL KINDS

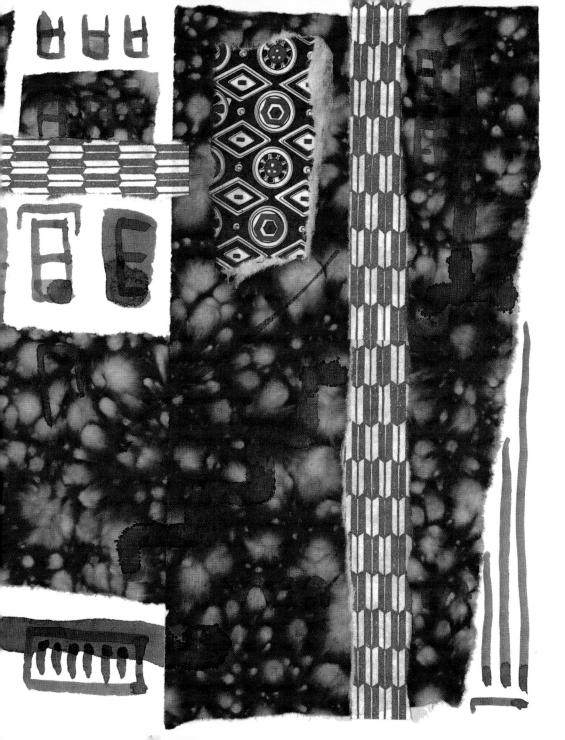

One flight up Della ran, and collected herself, panting. Madame, large, too white, chilly, hardly looked the "Sofronie."

"Will you buy my hair?" asked Della.

"I buy hair," said Madame. "Take yer hat off and let's have a sight at the looks of it."

Down rippled the brown cascade.

"Twenty dollars," said Madame, lifting the mass with

a

practised

hand.

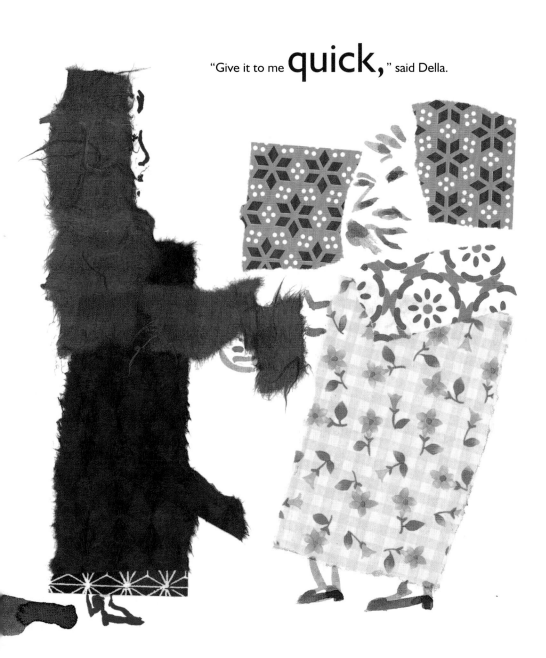

"Give it to me **quick**," said Della.

Oh, and the next two hours tripped by on **rosy** wings. Forget the hashed metaphor. She was ransacking the stores for Jim's present.

She found it at last. It surely had been made for Jim and no one else. There was no other like it in any of the stores, and she had turned all of them inside out. It was a platinum fob chain simple and chaste in design, properly proclaiming its value by substance alone and not by meretricious ornamentation—as all good things should do. It was even worthy of The Watch. As soon as she saw it she knew that it must be Jim's. It was like him. Quietness and value—the description applied to both. Twenty-one dollars they took from her for it, and she hurried home with the 87 cents. With that chain on his watch Jim might be properly anxious about the time in any company. Grand as the watch was, he sometimes looked at it on the sly on account of the old leather strap that he used in place of a chain.

When Della reached home her intoxication gave way
a little to prudence and reason. She got out her curling
irons and lighted the gas and went to work repairing the
ravages made by generosity added to love. Which is always
a tremendous task, dear friends—a mammoth task.

Within forty minutes her head was covered with tiny,
close-lying curls that made her look wonderfully like a truant
schoolboy. She looked at her reflection in the mirror long,
carefully, and critically.

"If Jim doesn't kill me," she said to herself, "before he takes a
second look at me, he'll say I look like a Coney Island chorus girl.
But what could I do—oh! what could I do with a dollar and
eighty-seven cents?"

At 7 o'clock the coffee was made and the frying-pan was on the back of the stove hot and ready to cook the chops.

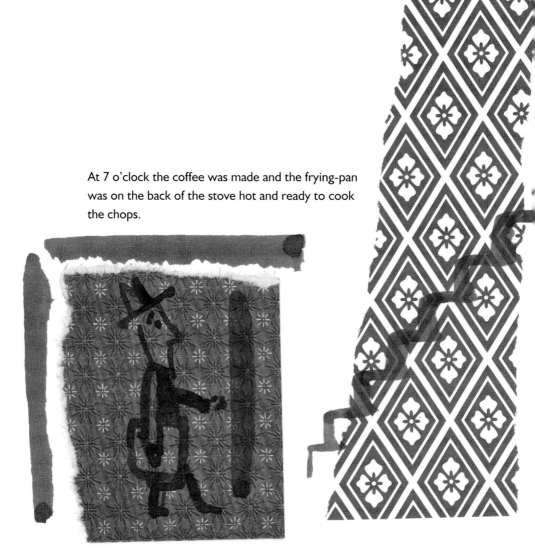

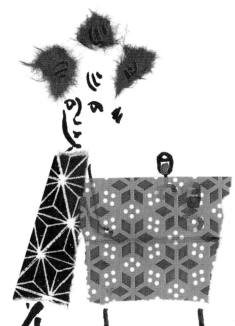

Jim

was never late. Della doubled the fob chain in her hand and sat on the corner of the table near the door that he always entered. Then she heard his step on the stair away down on the first flight, and she turned white for just a moment. She had a habit of saying little silent prayers about the simplest everyday things, and now she whispered: "Please God, make him think I am still pretty."

The door opened and Jim stepped in and closed it. He looked thin and very serious. Poor fellow, he was only twenty-two—and to be burdened with a family! He needed a new overcoat and he was without gloves.

Jim stopped inside the door, as immovable as a setter at the scent of quail. His eyes were fixed upon Della, and there was an expression in them that she could not read, and it terrified her. It was not anger, nor surprise, nor disapproval, nor horror, nor any of the sentiments that she had been prepared for. He simply stared at her fixedly with that peculiar expression on his face. Della wriggled off the table and went for him.

"Jim, darling," she cried, "don't look at me that way. I had my hair cut off and sold it because I couldn't have lived through Christmas without giving you a present. It'll grow out again— you won't mind, will you? I just had to do it. My hair grows awfully fast. Say 'Merry Christmas!' Jim, and let's be happy. You don't know what a nice—what a beautiful, nice gift I've got for you."

"You've cut off your hair?" asked Jim, laboriously, as if he had not arrived at that patent fact yet even after the hardest mental labor.

"Cut it off and sold it," said Della. "Don't you like me just as well, anyhow? I'm me without my hair, ain't I?"

Jim looked about the room curiously.

"You say your hair is gone?" he said, with an air almost of idiocy.

"You needn't look for it," said Della. "It's sold, I tell you—sold and gone, too. It's Christmas Eve, boy. Be good to me, for it went for you. Maybe the hairs of my head were numbered," she went on with sudden serious sweetness, "but nobody could ever count my love for you. Shall I put the chops on, Jim?"

Out of his trance Jim seemed quickly to wake.
He enfolded his Della.

For ten seconds let us regard with discreet scrutiny some inconsequential object in the other direction. Eight dollars a week or a million a year—what is the difference? A mathematician or a wit would give you the wrong answer. The magi brought valuable gifts, but that was not among them. This dark assertion will be illuminated later on.

Jim drew a package from his overcoat pocket and threw it upon the table.

"Don't make any mistake, Dell," he said, "about me. I don't think there's anything in the way of a haircut or a shave or a shampoo that could make me like my girl any less. But if you'll unwrap that package you may see why you had me going a while at first."

White fingers and nimble tore at the string and paper. And then an ecstatic scream of joy; and then, alas! a quick feminine change to hysterical tears and wails, necessitating the immediate employment of all the comforting powers of the lord of the flat.

For there lay The Combs—the set of combs, side and back, that Della had worshipped for long in a Broadway window. Beautiful combs, pure tortoise shell, with jewelled rims—just the shade to wear in the beautiful vanished hair. They were expensive combs, she knew, and her heart had simply craved and yearned over them without the least hope of possession. And now, they were hers, but the tresses that should have adorned the coveted adornments were gone.

But she hugged them to her bosom, and at length she was able to look up with dim eyes and a smile and say: "My hair grows so fast, Jim!" And then Della leaped up like a little singed cat and cried, "Oh, oh!"

Jim had not yet seen his beautiful present. She held it out to him eagerly upon her open palm. The dull precious metal seemed to flash with a reflection of her bright and ardent spirit.

"Isn't it a dandy, Jim? I hunted all over town to find it. You'll have to look at the time a hundred times a day now. Give me your watch. I want to see how it looks on it."

Instead of obeying, Jim tumbled down on the couch and put his hands under the back of his head and smiled.

"Dell," said he, "let's put our Christmas **presents** away and keep 'em a while. They're too nice to use just at present. I sold the watch to get the money to buy your combs. And now suppose you put the chops on."

The magi, as you know, were wise men—wonderfully wise men—
who brought gifts to the Babe in the manger. They invented the art of
giving Christmas presents. Being wise, their gifts were no doubt wise
ones, possibly bearing the privilege of exchange in case of duplication.
And here I have lamely related to you the uneventful chronicle of two
foolish children in a flat who most unwisely sacrificed for each other the
greatest treasures of their house. But in a last word to the wise of these
days let it be said that of all who give gifts these two were the wisest.
Of all who give and receive gifts, such as they are wisest.

Everywhere they are **wisest**.

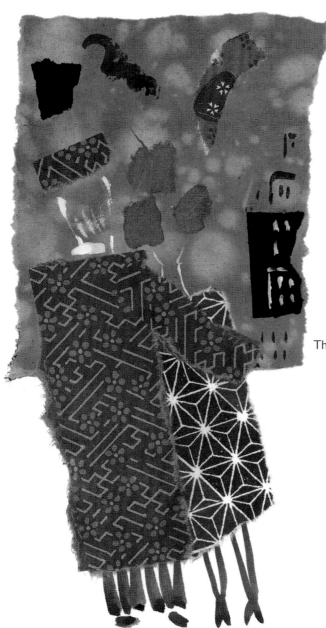

They are the magi.

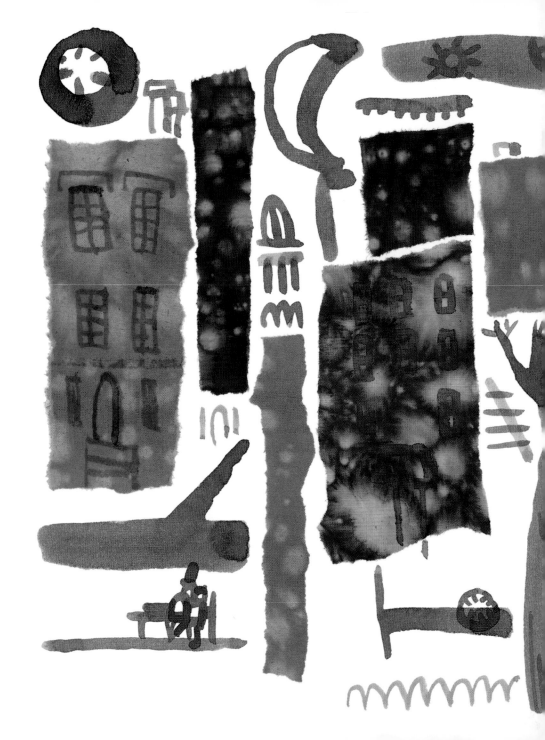

THE PURPLE DRESS

Now

that Mr. Gibson has gone let us get back to business. We are to consider the shade known as purple. It is a color justly in repute among the sons and daughters of man. Emperors claim it for their especial dye. Good fellows everywhere seek to bring their noses to genial hue that follows the commingling of the red and blue. We say of princes that they are born to the purple; and no doubt they are, for the colic tinges their faces with the royal tint as well as the snub-nosed countenance of a woodchopper's brat. All women love it—when it is the

fashion.

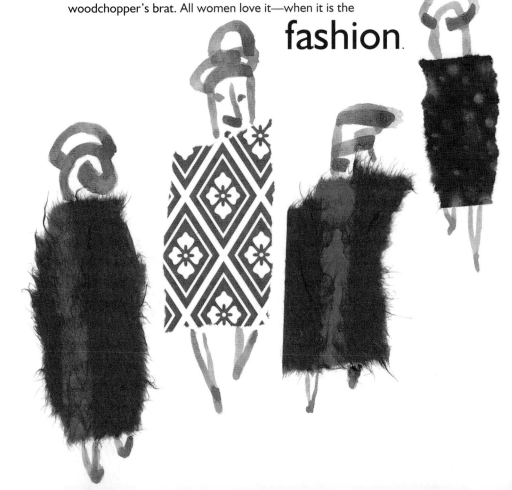

And now purple is being worn. You notice it on the streets. Of course other colors are quite stylish as well—in fact, I saw a lovely thing the other day in olive-green albatross, with a triple-lapped flounce skirt trimmed with insert squares of silk, and a draped fichu of lace opening over a shirred vest and double puff sleeves with a lace band holding two gathered frills—but you see lots of purple, too. Oh, yes, you do; just take a walk down Twenty-third Street any afternoon.

Therefore Maida—the girl with the big brown eyes and cinnamon-colored hair in the Bee-Hive Store—said to Grace— the girl with the rhinestone brooch and peppermint-pepsin flavor to her speech—"I'm going to have a purple dress—a tailor-made purple dress—for Thanksgiving."

"Oh, are you," said Grace, putting
away some 7½ gloves into the 6¾ box.
"Well, it's me for red. You see more red on
Fifth Avenue. And the men all seem to like it."

"I like purple best," said Maida. "And
old Schlegel has promised to make it for $8.
It's going to be lovely. I'm going to have a
plaited skirt and a blouse coat trimmed with a band of
galloon under a white cloth collar with two rows of—"

"Sly boots!" said Grace with an educated wink.

"—soutache braid over a surpliced white vest;
and a plaited basque and—"

"Sly boots—sly boots!" repeated Grace with an
educated wink.

"—plaited gigot sleeves with a drawn velvet
ribbon over an inside cuff. What do you mean by saying that?"

"You think Mr. Elkins likes purple. I heard him say yesterday
he thought some of the dark shades of red were stunning."

"I don't care," said Maida. "I prefer purple, and them that
don't like it can just take the other side of the street."

Which suggests the thought that after all, the

followers of purple

may be subject to slight delusions. Danger is near when a maiden thinks she can wear purple regardless of complexions and opinions; and when Emperors think their purple robes will wear forever; and when young men think they can flaunt the nasal emblazonry of the highball with success and impunity.

Maida had saved $18 after eight months of economy; and this had bought the goods for the purple dress and paid Schlegel $4 on the making of it. On the day before Thanksgiving she would have just enough to pay the remaining $4. And then for a holiday in a new dress—can earth offer anything more enchanting?

Old Bachman, the proprietor of the Bee-Hive Store, always gave a Thanksgiving dinner to his employees. On every one of the subsequent 364 days, excusing Sundays, he would remind them of the joys of the past banquet and the hopes of the coming ones, thus inciting them to increased enthusiasm in work. The dinner was given in the store on one of the long tables in the middle of the room. They tacked wrapping paper over the front windows; and the turkeys and other good things were brought in the back way from the restaurant on the corner. You will perceive that the Bee-Hive was not a fashionable department store, with escalators and pompadours. It was almost small enough to be called an emporium; and you could actually go in there and get waited on and walk out again. And always at the Thanksgiving dinners Mr. Ramsay—

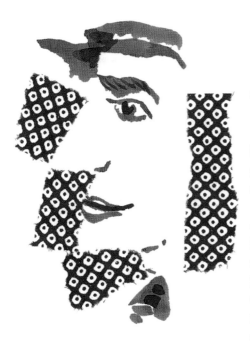

Oh, bother! I should have mentioned

Mr. Ramsay

first of all. He is more important than purple or green, or even the red of cranberry sauce.

Mr. Ramsay was the head clerk; and as far as I am concerned I am for him. He never pinched the girls' arms when he passed them in dark corners of the store; and when he told them stories when business was dull and the girls giggled and said: "Oh, pshaw!" it wasn't G. Bernard they meant at all. Besides being a gentleman, Mr. Ramsay was queer and original in other ways. He was a health crank, and believed that people should never eat anything that was good for them. He was violently opposed to anybody being comfortable, and coming in out of snow storms, or wearing overshoes, or taking medicine, or coddling themselves in any way. Every one of the 10 girls in the store had little pork-chop-and-fried-onion dreams every night of becoming Mrs. Ramsay. For next year old Bachman was going to take him in for a partner. And each one of them knew that if she should catch him she would knock those cranky health notions of his sky high before the wedding cake indigestion was over.

Mr. Ramsay was master of ceremonies at the dinners. Sometimes they had two Italians in to play a violin and accordion and had a little dance in the store.

And here were two dresses being conceived to charm Ramsay—one purple and the other red. Of course, the other three girls were going to have dresses too, but they didn't count. Very likely they'd wear some shirt-waist-and-black-skirt-affairs—nothing as resplendent as purple or

red.

Grace had saved her money, too. She was going to buy her dress ready-made. Oh, what's the use of bothering with a tailor—when you've got a figger it's easy to fit—the ready-mades are intended for a perfect figger—except I have to have 'em all taken in at the waist—the average figger is so large waisted.

The night before Thanksgiving came. Maida hurried home, keen and bright with the thoughts of the blessed morrow. Her thoughts were of purple, but they were white themselves—the joyous enthusiasm of the young for the pleasures that youth must have or wither. She knew purple would become her, and—for the thousandth time she tried to assure herself that it was purple Mr. Ramsay said he liked and not red. She was going home first to get the $4 wrapped in a piece of tissue paper in the bottom drawer of her dresser, and then she was going to pay Schlegel and take the dress home herself.

Grace lived in the same house. She occupied the hall room above Maida's.

At home Maida found clamor and confusion. The landlady's tongue clattering sourly in the halls like a churn dasher dabbling in buttermilk.

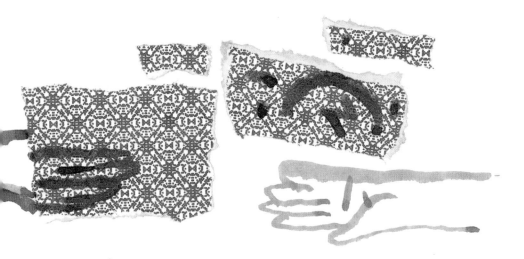

And then Grace came down to her room crying with eyes as red as
any dress.

"She says I've got to get out," said Grace. "The old beast. Because
I owe her $4. She's put my trunk in the hall and locked the door. I can't
go anywhere else. I haven't got a cent of money."

"You had some yesterday," said Maida.

"I paid it on my dress," said Grace. "I thought she'd wait till next
week for the rent." Sniffle, sniffle, **sob,** sniffle.

Out came—out it had to come—Maida's $4.

"You blessed darling," cried Grace, now a rainbow instead of
sunset. "I'll pay the mean old thing and then I'm going to try on my dress.
I think it's heavenly. Come up and look at it. I'll pay the money back,
a dollar a week—honest I will."

Thanksgiving.

The dinner was to be at noon. At a quarter to twelve Grace switched into Maida's room. Yes, she looked charming. Red was her color. Maida sat by the window in her old cheviot skirt and blue waist darning a st—. Oh, doing fancy work.

"Why, goodness me! ain't you dressed yet?" shrilled the red one. "How does it fit in the back? Don't you think these velvet tabs look awful swell? Why ain't you dressed, Maida?"

"My dress didn't get finished in time," said Maida. "I'm not going to the dinner."

"That's too bad. Why, I'm awful sorry Maida. Why don't you put on anything and come along— it's just the store folks, you know, and, they won't mind."

"I was set on my purple," said Maida. "If I can't have it I won't go at all. Don't bother about me. Run along or you'll be late. You look awful nice in red."

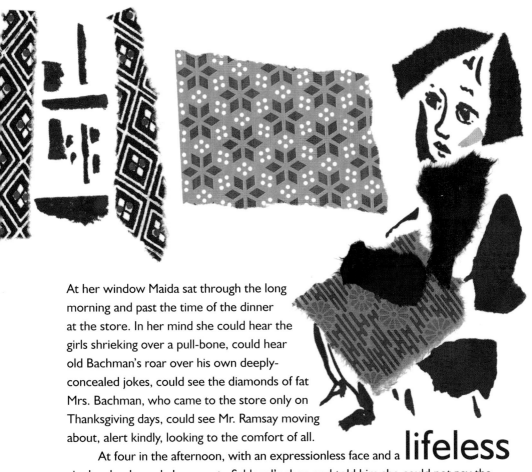

At her window Maida sat through the long morning and past the time of the dinner at the store. In her mind she could hear the girls shrieking over a pull-bone, could hear old Bachman's roar over his own deeply-concealed jokes, could see the diamonds of fat Mrs. Bachman, who came to the store only on Thanksgiving days, could see Mr. Ramsay moving about, alert kindly, looking to the comfort of all.

At four in the afternoon, with an expressionless face and a **lifeless** air she slowly made her way to Schlegel's shop and told him she could not pay the $4 due on the dress.

"Gott!" cried Schlegel, angrily. "For what do you look so glum? Take him away. He is ready. Pay me some time. Haf I not seen you pass mine shop every day in two years? If I make clothes is it that I do not know how to read beoples because? You will pay me some time when you can. Take him away. He is made goot; and if you look bretty in him all right. So. Pay me when you can."

Maida breathed a millionth part of the thanks in her heart, and hurried away with the dress. As she left the shop a smart dash of rain struck upon her face. She smiled and did not feel it.

Ladies who shop in carriages, you do not understand. Girls whose wardrobes are charged to the old man's account, you cannot begin to comprehend—you could not understand why Maida did not feel the cold dash of the Thanksgiving rain.

At five o'clock she went out upon the street wearing her purple dress. The rain had increased and it beat down upon her a steady, windblown pour. People were scurrying home and to cars with close-held umbrellas and tight buttoned raincoats. Many of them turned their heads to marvel at this beautiful, serene, happy-eyed girl in the purple dress walking through the storm as though she were strolling in a garden under **summer** skies.

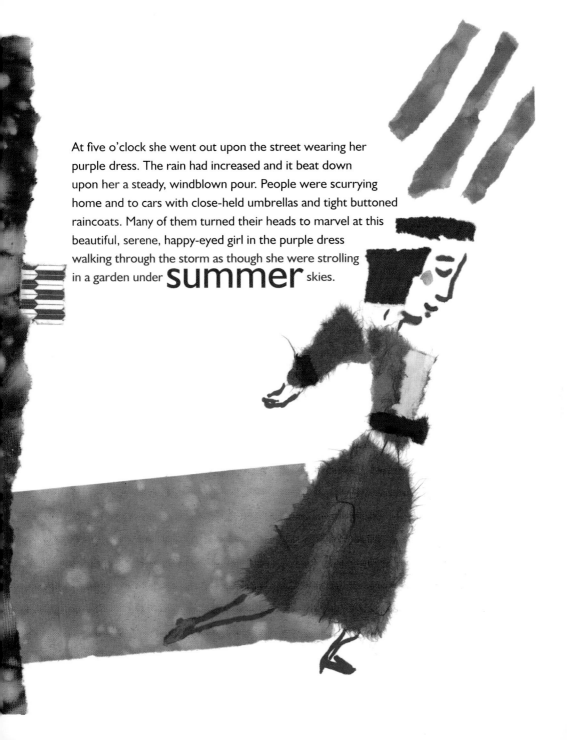

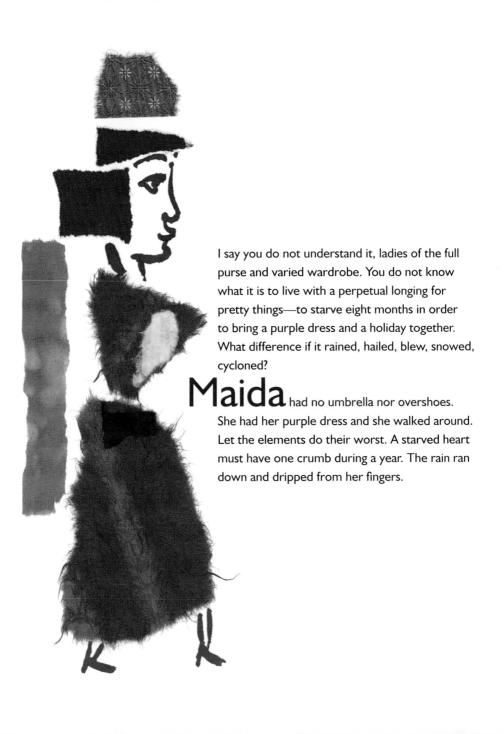

I say you do not understand it, ladies of the full purse and varied wardrobe. You do not know what it is to live with a perpetual longing for pretty things—to starve eight months in order to bring a purple dress and a holiday together. What difference if it rained, hailed, blew, snowed, cycloned?

Maida had no umbrella nor overshoes.

She had her purple dress and she walked around. Let the elements do their worst. A starved heart must have one crumb during a year. The rain ran down and dripped from her fingers.

Some one turned a corner and blocked her way.
She looked up into Mr. Ramsay's eyes, sparkling
with admiration and interest.

"Why, Miss Maida," said he, "you look
simply magnificent in your new dress. I was
greatly disappointed not to see you at our dinner.
And of all the girls I ever knew, you show the
greatest sense and intelligence. There is nothing
more healthful and invigorating than braving
the weather as you are doing. May I walk with you?"

And Maida blushed and sneezed.

THE GIFT OF THE MAGI / THE PURPLE DRESS
Text Copyright © 2006 by COLLINS DESIGN
Illustration Copyright © 2006 by Chris Raschka

HarperCollins books may be purchased for educational, business, or
sales promotional use. For information, please write: Special Markets
Department, HarperCollins Publishers, 10 East 53rd Street, New
York, NY 10022.

First Edition

First published in 2006 by:
Collins Design
An Imprint of HarperCollins*Publishers*
10 East 53rd Street
New York, NY 10022
Tel: (212) 207-7000
Fax: (212) 207-7654
collinsdesign@harpercollins.com
www.harpercollins.com

Distributed throughout the world by:
HarperCollins*Publishers*
10 East 53rd Street
New York, NY 10022
Fax: (212) 207-7654

Designed and typeset in **Gill Sans** and ENGRAVER'S ROMAN
by Shubhani Sarkar

Library of Congress Control Number: 2006925209

ISBN-10: 0-06-113880-0
ISBN-13: 978-0-06-113880-5

Manufactured in China
First Printing, 2006